The Royal Exchange Theatre presents

C H R I S T H O R P E
THERE HAS POSSIBLY BEEN AN INCIDENT

3 – 24 August

St Stephen's, Edinburgh

4 – 21 September, 2013

Royal Exchange Theatre, Manchester

24 September – 5 October, 2013

Soho Theatre, London

THERE HAS POSSIBLY BEEN AN INCIDENT
By Chris Thorpe

Cast

Gemma Brockis

Nigel Barrett

Yusra Warsama

DIRECTOR
Sam Pritchard

DESIGNER
Signe Beckmann

LIGHTING
Jack Knowles

SOUND
Sorcha Williams

For the Royal Exchange Theatre

SENIOR PRODUCER
Richard Morgan

COMPANY MANAGER
Lee Drinkwater

PRODUCTION MANAGER
Keith Broom

COSTUME SUPERVISOR
Felicia Jagne

Running time approximately sixty-five minutes with no interval

GEMMA BROCKIS is making her first appearance for the Royal Exchange Theatre. Gemma is a founder member of Shunt and has been in the core conception and devising team for all projects – THE ARCHITECTS, THE SHUNT LOUNGE, MONEY, AMATO SALTONE, TROPICANA, DANCE BEAR DANCE, THE TENNIS SHOW & THE BALLAD OF BOBBY FRANCOIS. With Silvia Mercuriali, she directs the company Berlin, Nevada, whose shows, PINOCCHIO and STILL NIGHT have toured internationally. Other theatre credits include: CROW (Greenwich Festival); SISTERS (The Gate Theatre); SPEED DEATH OF THE RADIANT CHILD (Plymouth Drum); NAPOLEON IN EXILE (Traverse Theatre); TWELFTH NIGHT (Camden People's Theatre); THE TEMPEST (Chris Goode); THE CONSOLATIONS (The Place, London); IT IS LIKE IT OUGHT TO BE (Uninvited Guests, China Tour); TANGLE (National Tour) and BAC ONE-ON-ONE FESTIVAL (Campinglis Bell-Hall).

NIGEL BARRETT is an associate artist with Shunt and associate director with Sulayman Al-Bassam Theatre Sabab. He is making his first appearance for the Royal Exchange Theatre. Other theatre work includes: A CONVERSATION (The Yard); RING (Fuel); THE ARCHITECTS, MONEY, THE TENNIS SHOW, THE SHUNT LOUNGE (Shunt); GET STUFF BREAK FREE (Made in China/RNT); BABEL, THE PASSION (National Theatre Wales and WildWorks); PERICLES (Regent's Park); SHELF LIFE (National Theatre of Wales); RICHARD III – AN ARAB TRAGEDY (RSC/Bouffes du Nord); CONTAINS VIOLENCE (Lyric Hammersmith); THE UNCONQUERED (Traverse Theatre); HIDE (Royal Festival Hall); THE HIGH ROAD (Clod Ensemble); AMATO SALTONE, TROPICANA (RNT/Shunt); THE MIRROR FOR PRINCES (Barbican); THE AL-HAMLET SUMMIT, MELTING THE ICE, MACBETH (Zaoum/Sulayman AlBassam Theatre); THE CHERRY ORCHARD (Young Vic Studio); A DIFFERENCE BETWEEN FRIENDS (Tour); SINGLE SPIES (Theatre Royal Bath); PLAYING WITH FIRE, FIVE VISIONS (White Bear); MISS JULIE (Someone Else Theatre); INCARCERATOR (BAC); PYGMALION (Tour de Force); RABBIT PUNCHING, BURGLAR BEWARE (Grip Theatre); AN IDEAL HUSBAND, CYMBELINE (Bear Gardens); ANIMAL FARM (Lamplit Theatre); CAMI (Gate Theatre); EVERYMAN (Sulayman Al-Bassam/Cochrane Theatre); JUST POPPED OUT (Boilerhouse Theatre); THE PIGEON BANQUET (Waterman's Theatre); A FISH IN WATER (Camden People's Theatre); A MIDSUMMER NIGHT'S DREAM (Travelling Players). Nigel has also created work with artist Louise Mari – THE ONE MAN SHOW, THE BODY, NIGEL AND LOUISE'S FESTIVAL OF ADVENTURES, STANDER and A CONVERSATION. Film and television work includes: CYCLES, THE GOSPEL OF US, THE BOAT, HELLO YOU, CASUALTY, CRIMEWATCH, MEET THE PILTDOWNS, HAIRY EYEBALL, DAWSON'S CREEK SPECIAL, THE MYSTERIES, DEADLINE, THE LENS, SEXUAL HEALING, ENGLAND, MY ENGLAND. Radio includes: THE INFLUENCE, THE LIFE OF EDMUND SHAKESPEARE and RICHARD TYRONE JONES' BIG HEART.

YUSRA WARSAMA is making her first appearance for the Royal Exchange Theatre. Other theatre credits include: SONNET SUNDAY (The Globe); SHARED MEMORIES (rehearsed reading, Kali Theatre/The Curve); CRYSTAL KISSES, EVERYONE WATCHES TV, SUMMER LOVE (Contact Theatre, Manchester); NEW WRITING FESTIVAL (The Curve); BULLETPROOF SOUL (rehearsed reading), BOLT-HOLE, THREE WAY (Birmingham Rep); TWO TONE (West Yorkshire Playhouse); CARRI MI ACKEE (Free Expression Dance); EXPOSED (Apples & Snakes); GRACE, MAKE BELIEVE (Quarantine); SPEAKERS' CORNER (Don Letts); THE GIRL WHO LOST HER SMILE (Tutti Frutti). Television credits include: DRACULA (NBC), GOOD COP and POSTCODE. Film credits include: LAST DAY ON MARS, MY BROTHER THE DEVIL and STOLEN. Radio includes: ODOUR and LEGACY (BBC Radio 4), GOVERNMENT BY MAGIC SPELL (THE HUMAN CRADLE SERIES) and AMAZING GRACE. Yusra has recently been nominated as a Screen International Rising Star.

CHRIS THORPE (Writer) Chris Thorpe is a writer and performer from Manchester. He was a founder member of Unlimited Theatre and still works and tours with the company. He is also an Artistic Associate of live art/ theatre company Third Angel as well as working closely with, among others, Forest Fringe, Slung Low, Chris Goode, RashDash, Belarus Free Theatre and Portuguese company mala voadora for whom he has just completed a trilogy of new plays. He has an ongoing collaboration with poet Hannah Jane Walker, and their shows THE OH FUCK MOMENT and I WISH I WAS LONELY are also published by Oberon Books. As a playwright Chris has written radio and stage drama, as well as translating the work of Ugljesa Sajtinac (the play HUDDERSFIELD is also published by Oberon), Belarus Free Theatre, and Ze Maria Mendes. He also writes and performs solo work, plays guitar in the political noise/performance project #TORYCORE and works as a selector for the National Student Drama Festival.

SAM PRITCHARD (Director) was the New Writing Associate at the Royal Exchange Theatre between 2010 and 2012, where he ran the theatre's new writing programme and the Bruntwood Prize for Playwriting 2011. He is the winner of the JMK Award for Young Directors 2012. Work as a Director includes: FIREFACE (Young Vic), GALKA MOTALKA (Royal Exchange Studio), MONEY MATTERS (nabokov/Soho Downstairs) and THE PARROT HOUSE (Liverpool Everyman/Everyword Festival). Work as an Associate or Staff Director includes: WOZZECK (ENO), A DOLL'S HOUSE (Young Vic/West End), PAPER DOLLS (Tricycle Theatre).

SIGNE BECKMANN (Designer) Signe Beckmann was born in Denmark and trained at the Motley Theatre Design Course. Theatre credits include: MOLLY SWEENEY (The Print Room); LARISA AND THE MERCHANT (Arcola Theatre); THE THING ABOUT PSYCHOPATHS (Red Ladder Theatre); COMEDY OF ERRORS (Cambridge Arts Theatre); AMERICAN JUSTICE (Arts Theatre, West End); THE SERPENT'S TOOTH (Almeida/ Shoreditch Town Hall); INSUFFICIENCY (Riverside Studios); PEEP (Pleasance,

Edinburgh); BENEFACTORS (Sheffield Crucible); THE MAN WITH THE DISTURBINGLY SMELLY FOOT (Unicorn Theatre); MATHEMATICS OF THE HEART (Theatre503); THE GLEE CLUB (Hull Truck); THE KNOWLEDGE, LITTLE PLATOONS (Bush Theatre); CRAWLING IN THE DARK (Almeida Projects); GHOSTS (Young Vic); KING UBU (Corona La Balance, Denmark); DANCING AT LUGHNASA (Aubade Hall, Japan). Opera credits include: THE TURN OF THE SCREW (OperaUpClose); LA SERVA PADRONA (Sa de Miranda, Portugal), VOLUME (ENO Opera Works, Sadler's Wells), EUGENE ONEGIN, GIASONE (Iford Arts). Dance credits include: GAMESHOW (Company Chameleon, The Lowry), QUIPROQUO (Rapid Eye, Denmark); MERIDIAN and PHANTASY (Rambert Company, Queen Elizabeth Hall). Screen credits include: THE CLUB, PLAN B - KILLA KELA, CENTREPOINT (Mike Figgis) and the Headlong Theatre 2013 Season Trailer (Rupert Goold). Current projects include: Costume Design for DON GIOVANNI at the Royal Danish Opera.

JACK KNOWLES (Lighting Designer) trained at The Central School of Speech and Drama. Recent credits include: MOTH (Hightide/Bush); SAY IT WITH FLOWERS (Hampstead Theatre); YELLOW WALLPAPER (Schaubühne Berlin); THE CHANGELING (Young Vic, with James Farncombe); TOMMY (Prince Edward Theatre); REISE DURCH DIE NACHT (Halle Kalk, Shauspiel Köln); BLINK (Traverse/Soho Theatre); MARK THOMAS: BRAVO FIGARO (Traverse & UK Tour); IN A PICKLE (RSC/Oily Cart); THIN ICE (UK Tour); THE RIOTS (Tricycle Theatre); RING-A-DING-DING (Oily Cart, Unicorn Theatre & New Victory Theatre New York); YOUNG PRETENDER (Watford Palace & UK Tour); VICTORIA (Arts Ed); THE BOY ON THE SWING (Arcola); IMPERIAL FIZZ (Assembly Rooms); ROOM (Tron); ONE THOUSAND PAPER CRANES (Imaginate Festival); MY NAME IS SUE (Soho Theatre & UK Tour); IF THAT'S ALL THERE IS (UK & International Tour); RED SEA FISH (59E59 New York); HANGING BY A THREAD (UK Tour); LOVE'S LABYRINTH (Opera Restor'd); A GUEST FOR DINNER (Arts Depot). Recent Associate credits include: AL GRAN SOLE CARICO D'AMORE (Berlin Staatsoper); THE BOMB (Tricycle Theatre); SALT, ROOT AND ROE (Donmar Trafalgar); DIE WELLEN (Shauspielhaus Köln); AFTER DIDO (ENO/Young Vic).

SORCHA WILLIAMS (Sound Designer) has had a varied career that spans TV, Film, Musical Theatre and live events. Her current position as Senior Sound Technician at The Royal Exchange Theatre has opened up a range of design opportunities including JOHNNY COME LATELY (Coal in association with Royal Exchange Theatre) and with Education projects THE CHILDREN'S SHAKESPEARE FESTIVAL 2012 & 2013 and THE SALFORD TELEVISION WORKSHOP PROJECT SHOWCASE 2013, in addition to working alongside some of the leading Sound Designers in the UK.

Royal
Exchange
Theatre

Situated in the heart of Manchester, the Royal Exchange is one of the UK's leading producing Theatres. We are home to two performance spaces: a 750 seat glass and steel in-the-round Theatre and a 100 seat flexible Studio space. We produce up to twelve productions a year alongside a diverse touring programme of work.

We nurture outstanding creative talent in our city and attract some of the most original artists and theatre makers in the country to present high quality classic plays and new writing to entertain, provoke and inspire. We provide opportunities for people of all ages, backgrounds and abilities to explore and develop their creative imaginations in our iconic building.

THERE HAS POSSIBLY BEEN AN INCIDENT premiered at St Stephen's as part of the Edinburgh Fringe Festival in August 2013 and then transferred to The Studio at the Royal Exchange Theatre Manchester from 4 – 21 September, followed by the Soho Theatre, London from 24 September – 5 October 2013.

Royal Exchange Theatre, St. Ann's Square, Manchester, M2 7DH
royalexchange.co.uk
+44 161 833 9333
Logos: AGMA, Manchester City Council, ACE
Registered Charity Number 255424

Royal Exchange Theatre Staff

BOX OFFICE
Box Office Manager
Sue Partington
Deputy Box Office Manager
Wendy Miller
Box Office Assistants
William Barnett, Jon Brennan,
Lindsay Burke, Graeme Cole,
Dan Glynn, Zoe Nicholas,
Christine Simpson,
Eleanor Walk

BUILDING & EVENTS
Building & Events
Co-ordinator
Philip Lord
Maintenance
Rodney Bostock
Housekeeper at the
Directors' Flat
Jackie Farnell

CASTING
Casting Director
& Associate Director
Jerry Knight-Smith CDG

CATERING
General Manager
Peter Hand
Bars Manager
Chris Wilson
Cafe Manager
Kieron Carney
Duty Managers
Alastair Smith, Jake Tysome
Head Chef
Chris Watson-Gunby
Bar and Catering Staff
Mohammed Ahmed, Chloe
Baulcombe, Mark Beattie,
Hannah Blakely, Mazz Brown,
Paul Callaghan, Leah Curran,
Oliver Devoti, Scott Foulds, Jake
Gamble, Chris Gray,
James Green, Abigail Henshaw,
Joseph Leacock,
Simon Mayne, Rafal
Michnikowski, Chloe Nugent,
Jenny Nuttall, Matt Nutter, Tom
Redshaw, Paul Roberts, Mark
Smith, Camille Smithwick

COMPANY
Company Manager
Lee Drinkwater

COSTUME HIRE
Costume Hire Manager
Ludmila Krzak

CRAFT SHOP
Craft Shop Manager
Rachael Noone
Assistant Manager
Gail Myerscough
Assistants
Chloe McCarrick, Elisa
Robinson, Clare Sidebotham,
Frankii Tonge

DEVELOPMENT
Development Director
Marla Cunningham
Senior Development
Manager
Gina Fletcher
Development Manager
Ruth Paterson

Development Officer
Becky Rosenthal

DIRECTORATE
Artistic Directors
Greg Hersov, Sarah Frankcom
Executive Director
Fiona Gasper
Senior Producer
Richard Morgan
Assistant to the Artistic
Directors & Senior
Producer
Michelle Hickman
Assistant to the Executive
Director & Director of
Finance & Admin
Jan-Louise Blythe

EDUCATION
Education Director
& Associate Director
Amanda Dalton
Education Producer
Chris Wright
Education Administrator
Katharine Reynolds
Schools' Co-ordinator
Jane Purcell
Young People's Co-
ordinator
Rebecca Hine
Community Co-ordinator
Ben Turner
Education Admin Assistant
Emma Wallace

FINANCE
Director of Finance &
Administration
Barry James
Accounts Manager
Lesley Farthing
Orders & Purchase
Ledger Clerk
Jennifer Ellis
Payroll Clerk
Carl Robson

FRIENDS ORGANISATION
Friends' Organiser
Janet Aslan

FRONT OF HOUSE
Theatre Manager
Irene Muir
Front of House Manager
Lynne Yates
Deputy Front of House
Manager
Stuart Galligan
Relief FOH Managers
Jill Bridgman, Julian Kelly,
Stuart Shaw
Relief Deputy Managers
Helen Coyne, Chris Dance,
Dan Glynn, Eleanor Walk
Security
David Hughes, Peter Mainka
Stage Door
Alan Burrough, Thomas Flaherty,
Laurence McBride
Head Cleaner
Lillian Williams
Cleaners
Gillian Bradshaw, Susan
Burrough, Elaine Connolly, Val

Daffern, Shaun Driver Georgina
Dwyer, Jackie Farnell, Esther
Greis, Shery Yusuf

USHERS
Liam Ainsworth, Mike Belton,
Anthony Burke, Richard
Challinor, Simon Cookson,
Laura Cope, Helen Coyne,
Christopher Dance, Anna
Davenport, Rachel Davies,
Cliona Donohoe, Hazel Earle,
Luther Edmead, Paul Evans, Neil
Fenton, Vita Fox, Beth Galligan,
Daniel Glynn, Alistair Hardaker,
Jamie Leigh Hargreaves, Davinia
Jokhi, Alison Jones, Lee Joseph,
Julian Kelly, Dan Lizar, Tony
O'Driscoll, Shereen Perera,
Annie Roberts, Genevieve Say,
Mike Seal,
Abigail Standing, Dan Taylor,
Vincent Tuohy, Mahdi Zadeh

GREEN ROOM
Supervisor
Yvonne Stott
Assistant
Anne Dardis

INFORMATION
TECHNOLOGY
IT Manager
Ean Burgon

LITERARY
New Writing Associate
Suzanne Bell
Literary Admin Assistant
Sam Stockdale
Pearson Writers in
Residence
Cat Jones
Bruntwood Hub Associate
Playwright
Bryony Lavery
Hub Salon Playwrights
Katie Douglas, Aisha Khan, Lee
Mattinson, Alistair McDowall,
Ben Tagoe, Tom Wells

LIGHTING
Head of Lighting
Richard Owen
Deputy Head of Lighting
Kay Haynes
Lighting Technicians
Alex Dixon, Laura Howells

MARKETING
Director of Marketing
& Communications
Claire Will
Head of Marketing
Vanessa Walters
Design & Print Manager
Maxine Laing
Press & Communications
Manager
John Goodfellow
Marketing Officer – Digital
& Systems
Vicky Bloor
Marketing Officer – Groups,
Education & Development
Eleanor Higgins
Marketing Assistant
Anneka Morley
Archivist (Volunteer)
Stella Lowe

PRODUCTION
Production Manager
Simon Curtis
Production and Buildings
Administrator
Sue Holt
Production and Buildings
Assistant
Greg Skipworth
Props Buyer
Kim Ford
Driver
John Fisher

PROPS & SETTINGS
Head of Props & Settings
Neil Gidley
Deputy Heads of Props
& Settings
Andrew Bubble, Philip Costello
Prop makers
Carl Heston, Stephen Lafferty,
Stuart Mitchell, Meriel Pym,
Sarah Worrall

SOUND
Head of Sound
Steve Brown
Senior Sound Technician
Sorcha Williams
Sound Technicians
Ben Almond, David Norton

STAGE TECHNICIANS
Technical Manager
Lee Pearson
Studio Technical Manager
Keith Broom
Technicians
Joe Clifford, David Ford

WARDROBE
Head of Wardrobe
Nicola Meredith
Deputy Head of Wardrobe
Tracey Dunk
Acting Deputy Head of
Wardrobe
Felicia Jagne
Cutters
Rachel Bailey, Jennifer Adgey
Tailor and Gents Cutter
Rose Calderbank

WARDROBE
MAINTENANCE
Maintenance Wardrobe
Mistress
Kate Elphick
Maintenance Wardrobe
Assistant
Michael Grant

WIGS
Wigs & Make-up Supervisor
Rowena Dean
Wigs & Make-up Assistant
Jo Shepstone

YOUNG COMPANY
Georgia Abel, Oliver Appleyard-
Keeling, Eleanor Bacon, Tiffany
Zara Bowman, Jack Braniff,
Louis Brierley, Mekisha Brown,
Jason Cameron, Grace Cassidy,
Samson Clarke, Madeline
Cole, Mike Cooper, Frances
Cousins, Hannah Donelon,
Teresa Duggan, Laurence Farrell,
Sarah Fielding, James Forshaw,

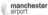

Mrs S M Ireland
Mr Lee Jefcott
Mrs Ruth Johnson
Barbara Jones
Mr Ben Jones
Mr Elis Jones
Mr Ian Jones
Paul Jones
D Kealey
Dr Angela Keane
P R Kelly
Andrea King
Miss Janet Lawley
Mr & Mrs W Lea
Mrs Caroline Light
Mrs C Linguard
Ms Helen Little
A Livesey
Mr & Mrs K Lonergan
Jacquie & David Long
Mr Martin Losse
Mr E Loupos
Mrs E G Lowe
J Lowe
Mrs Stella Lowe
Mr Anthony Maber
Miss S A Malone
Mr Jon Mason
Mr Derek Mather
Martin McArthur
Dr R A McCann
Mrs S McCarthy
Mr Peter McEvitt
Mr Alastair McGowan
E A McLean
Ms Vivien McNamee
Mr Simon Midgley
Mr Kevin Miller
Dr Kaye Mitchell
Mrs Jennifer Molden
Mr G M Morton
Mr P T Moss
Mrs E P Neill
D Nott
Mrs Gill Owen-John
Richard Payne
Mr John Pearson
Mrs June Pickering
Mrs J Porgess
Ms A M Poynton
Ms Jacqueline Pratt
Mrs Maria Price
Mr T J Quinn
Ms V J Ralphs
Mrs Angela Rimmington
Mrs Linda Robinson
Mrs Rosemary Rosenthal
S Royle
Mr D Rumney
Ms Stella Salmon
J A Say
Ms K Schofield
Dr Gillian Scragg
John Sharp
Father Paul Shaw
Mrs Lorna Shea
Mrs Emma Sheldon
Mr Robert Shenton
Mr Simon Sinclair
Mrs Alison Smallridge
Mr Bryan Smith
Mr & Mrs C R & H I L Smith

Mr Hugh Smith
Dr Rob Spence
Margery Spencer
Mrs D Spruce
Mr Clive Staton
M Stone
John Stott
Mrs G Stringer
Les Stringer
Mark Sykes
Mr Roger Tarling
Ms Laura Tatham
J T Taylor
P T Taylor
Mr P W Thomas
Mr John Turner
Mr Ian Visser
Mr Stephen Walker
Mrs Joyce Walsh
Dr K Walton
Mr Garry Ward
Ray Waterhouse
Elizabeth Wetherall
C Wightman
Mr Bernard Wildman
Mrs Shirley Williams
Mr John Wilson
N Winterton
Mrs Maureen Workman
Miss Nikita Wright-O'Donnell

PLAQUE DONORS

FLOOR PLAQUES
Addleshaw Booth & Co (now Addleshaw Goddard)
Anne E Al-Othman
Mohammed Amin
Michael Arditti
Sam & Carol Arditti
Mr Gordon Aspey FRCA & Mrs Diana Aspey – Millennium 2000
AstraZeneca
Greg Atkinson, 1957-2010 Cherished Memories
Mike Badham 1929-2007. Beloved nephew, husband, father.
Prof. Deborah Baker, 1949 - 2009, Loved beyond words
Gerry Ball & Brian Tooley
Anna Jill Bennett
John Bennett 1953 – 2002
Berrymans Lace Mawer
The Blackburn Family – In Memory of Michael
Bosal
Bruce Bowley on the occasion of his 50th birthday - 12.12.2010
Arnold and Brenda Bradshaw
In Memory of Dennis Branham who enjoyed many visits to this special theatre
In loving memory of Naomi Buch, Actress
Dr Richard L Bunning
From the Friends & Family of Karina Burden & Michael brookes on the occasion of their wedding 1 November 1998
Dr Peter Burgess – A Manchester man
Alfred Burke 1918-2011 Player on this stage fondly remembered.

Dr Norman Calder 1950 – 1998
Grace Carroll
Sophie Carroll
My beautiful Cathy. I love you so much. Bryn xxxxx
George William Catlow 1937 – 2000
David & Mary Clarkson
Bethan Louise Clayton 30.12.86 – 17.02.87
Closomat
Rita Cohen
In memory of Michael Cohen – who loved the Theatre
Communique PR
John & Betty Comyn-Platt
Meg Cooper – For 25 good years, love Peter 2 April 2002
Dorothy Cornwall-Leigh – who loved this place
J K Cowgill
Ian R. Crownshaw who lit up our lives 1962 – 1996
Dr BG Daniels "Only dull people are brilliant at breakfast" 1937 – 2000
Darren & Amanda «To live in the hearts we leave behind» Your loving family
Leslie & Marjorie Davies
Doreen & Bert Dawson. All is Well.
Deloitte & Touche
Philip Roy Dewings
Disabled Care Services
Richard S Downs Da mihi castitatem et continentiam, sed noli modo. Happy 60th Birthday on May 23, 2011
Remembering Norman Hartley Duerden (1 July 1926 - 5 October 2007) - who loved this Theatre
E. Ann Durant, 1934-2009, Chair GMC Museum & Arts Committee, Founding Patron of the Royal Exchange Theatre
Sonia Dykstra
Elliotts Solicitors
Patrick Farrell's Thirtieth Birthday 23rd September 2003
Peter & Judy Folkman
Suzanne Furniss 1940 – 2000 With Thanks to Philip Geiger
Eileen Ghaneh - a special birthday
Angela & Frank Glendenning
Granada Television
Ernest Greenwood 22.2.1914-9.2.1986 Elizabeth Ella (Dolly) Greenwood 20.4.1920-2.1.2011 Roy and Maria Greenwood, Silver Wedding Anniversary, 17 October 2009
Annie Greer - Celebrating 30 years of this magical space
Audrey Gregory
Presented by Erwin Grossman in memory of Yidl, Julius & Helen Grossman who introduced him to the delights of the theatre
GUS
Halliwell Landau (now Halliwells LLP)

Halo proud to be celebrating our 30th year. Donated through Express yourself with Halo and wife
Hammond Suddards
Margaret Hanly 1939-2012
Stephen P Hanson – a beloved man who loved the Arts
Thelma & Charles Hardy
Geoff & Jennie Holman
John Hook 17.9.1944 - 21.8.2001
Mrs Sonia Hopkinson
Russ Hudson
Brian Ingham 1936 – 2005 Lover of all Theatre
Dr Richard T Johnson
Sue Jones – Supporter of the Arts
David E S Kaye 'An Ideal Husband'
In Memory of Dorothy Knowles Theatre Lover
A dedication to Terry Lardner 1937 – 2000
In Memory of Pierce Joseph Lawlor
Antonia Lee
Jonathon Lee
Liz & Paul Lee
William Lee
Garth Lindrup
London Scottish Bank plc
Erika Loupos
Jack Lynch, remembered with love by Margaret & Conrad
Jon Marks
Marmont Management plc
Martin, Frances & Zoe
Jean & Jim Martin
David & Mary McKeith
Bill McMullen
Peter Molins 1936 – 1995
Allan Monkhouse 1858 – 1936, Dramatist of the Manchester School
Gladys Morrision Lewis 1917 - 2009 Beloved wife, aunt, great-aunt.
Mrs Elsie Morton
Mr & Mrs D Mundy
For My Daughter-In-Law, Shirley Murtagh, With Love Winifred
Vivien Katherine Murton 1945 – 2004 – "for my remembered pleasure"
Mr E Mustard
Amos Nelson Ltd
Pauline & Tony Oldershaw
Bridgid O'Hagan - Manchester's Gem, with much love from her friends
Christine Ann Ovens
Thelma L Owen
Daphne Oxenford and David
Marshall Sophie and Kate
Eric & Elaine Paget
Pannone & Partners
John & Margaret Pearsall
JAMES PENDLEBURY a.k.a James Personal Tailor
Alan C Pickwick
Patsy Pringle

For the beautiful Chloe Pugh 'How wonderful life is now she's in the world'
Sue, Nick and Rebecca Pye
Monica Raffle
RED Production Company, Manchester
Gerda Redlich
Dr Linda Reynolds 1950-2000
The R A Roberts Partnership Ltd
Frank & Beverley Robinson
Michael & Shiela Roe 2004
Tim Rouledge 1945 – 2002
The Royal Bank of Scotland J Salisbury 1937 – 2000 in memory of a loving theatre-goer
Jack Schnider 1939 – 2003
Kenneth Scowcroft DL
In memory of, Derek Shepherd 1928-2011, Katherine Shepherd 1928-2012
The Family of Gay & Geoffrey Shindler
Albert Sidi Cotton Merchant
In loving memory of George Singleton 1911 – 2003
Trevor & Mary Stockton
Marjorie Sudell
In loving memory of Alex Susman-Shaw 2009
Campbell Tait
Tattersall Cotton Trade Experts
John Thaw
The Thomas Girls
Doreen Thompson/1929-2007/Our mum, our Nana, our friend
Prof. Harry Tomlinson 1939 – 2005
Esme Rose Torevell Born 30 May 2007
Jasmine Eve Torevell Born 19 March 2004
William James Torevell Born 20 November 2002
Total Hygiene
In memory of Alvys Margaret Twelves 1939 -2010 with love from her daughters
James and Elizabeth Vernon Jago 1879 – 1923 / 1883 – 1971
For Tommy Vine, our beautiful spark. You are much missed. With love and great respect from your BEAUTIFUL THING and COUNTRY WIFE company members.
Mr & Mrs P Whitby
Kenneth Cooper Wilde 1927-2012, Cotton Yarn Salesman, former member of the Exchange.
Sheila Williams 1938 – 2006 K.M.W. who loved this theatre and all it stands for.

Tom Woodcock Site Manager
Will Young, THE VORTEX 2007, From his fans
In memorium Casper Wrede and Dilys Hamlett, founding artists of the RTE Co, let their vision, craft and integrity be a guide to all those who follow in the use of this great space. All our love, David, Orla, Ciara Wrede.
John & Brigid Zochonis

SEAT PLAQUES
Max Adrian, Actor
W F & D Y Aplin
Pamela Bentwood
Stephanie Bidmead
The Black Family
Tony & Mary Black
In Memory of E Peter Brown
Norman & Hazel Buckley
Tracy Burns
Joy C
Dorothy Carline
Mr & Mrs R M G Carter
Castlemere Properties Ltd
Cheadle Hulme School
Harold Clayton
Dame Judi, Michael &Finty
Sir Peter Daubeny
In Memory of Marion Davies who loved this theatre
Bernard De Sousa
Julia De Sousa
Terry Dillon 1942-1986
Andrea Ellis
Ronald Eyre
K & R B Farmery
John & Alison Gosling
Joyce Grenfell
Love Endures Eileen Griffiths 27 April 1929–11 May 2010
Supporters since 1974, David & Muriel Heslop
Frankie Howerd
Rod & Tessa Howgate
Jack & Christina Howley
HRH The Prince of Wales
Mrs Annabelle E C Hull
Irlen Centre
The Jaqueline& Michael Gee Charitable Trust
Carol Keepe, Charles Keepe, John Garstang
Amin Kiami
Pamela Kiami
Esmond Knight
Wilfrid Lawson
Mr & Mrs L D Lawton
In Memory of Lawrence Lewis
Mrs Colette Levy
Mr Ralph Levy
Mrs Sybil Levy
In Memory of Nancy Loughran
Erika Loupos
Mary R Lowe

H Mallalieu
David & Sue Mason
James Mason
Lynda A Mason BA (hons)
In Memory of Jim & Emily McDonald
Peter & Dorothy McDonald
Amanda Meyer
Joanna Meyer
Nora Meyer De Haan
Dr Richard Meyer
In Memory of Victor Morton
Mr P Moulds
Megan & Arthur Neesom – In Friendship
Paul Neesom – In Friendship 1953-1987
Christine Ovens
In Memory of Gerard Owens
Daphne Oxenford
Elsie P
Graham D Pearl
In ainm Brian Phelan Fuair Bas 1995
AoisSeachtdeag
Mary & Leslie Preston
Anne & David Purves
In Memory of Brian Quiggin
The Richard Stone Partnership
Jack Ripley
The Rogersons
Leslie Rostron
The Sidi Family
Catherine Simmons
Mr C G H Simon
Alan & Mary Smith
In memory of Harry Smith
Beryl Steinberg
Joan Stepto
R F T Stepto
Clare Stuart
Clare Lisa Swillingham
E Thomas
S Thomas
In Memory of Joan Thomassin
Ron Townley
Daphne-Ann Wade
In Memory of Mandy Wigodsky
Pamela Wilkins Piglit/ Grandma Piglit with love
Sir Donald Wolfit, Actor 1902–1968
In Loving Memory of Wilfred Verber 1911–1977

BENEFACTORS SCHEME
The Benefactors Scheme ran until 2003 as a way for donors to support the ongoing work of the Royal Exchange Theatre following the Theatre's major refurbishment programme

SILK BENEFACTORS

Accenture
Addleshaw Goddard & Co
Airtoursplc
Anonymous for the Michael Elliot Bursary for Trainee Directors
The Arthur Andersen Foundation
Birse Construction Ltd
BNFL
Co-operative Group
Co-operative Retail Services
Co-operative Wholesale Society
Esmée Fairbairn Foundation
The Granada Foundation
Granada Television in support of Artistic Training
KPMG
Marks & Spencer for the Marks & Spencer Design Bursary
Norwebplc
William Hare Ltd
The Zochonis Charitable Trust

LINEN BENEFACTORS
Anonymous
CIS (Co-operative Insurance)
The Foundation for Sport and the Arts
The Foyle Foundation
Garfield Weston Foundation
The Jack Livingstone Charitable Trust
The John Ellerman Foundation
N M Rothschild & Sons Ltd
North West Water
Paul Hamlyn Foundation
George P Proffitt

COTTON BENEFACTORS
Frances & Barrie Bernstein
Mr Joe Dwek
Edmundson Electrical Ltd
The Equity Trust Fund
The Harold Hyam Wingate Foundation under the Channel 4 Director Scheme
The John S Cohen Foundation
Lex Service plc
N Brown Group plc
The Nicholas Hytner Charitable Trust
Price Waterhouse
Refuge Assurance plc
Royal London Group
The Rufford Foundation
SCAPA Group
Siemens plc
Silentnight Holdings plc
The Stoller Charitable Trust
The Trusthouse Charitable Foundation
United Assurance Group plc

London's most vibrant venue for new theatre, comedy and cabaret.

Soho Theatre is a major creator of new theatre, comedy and cabaret. Across our three different spaces we curate the finest live performance we can find, develop and nurture. Soho Theatre works with theatre makers and companies in a variety of ways, from full producing of new plays, to co-producing new work, working with associate artists and presenting the best new emerging theatre companies that we can find. We have numerous writers and theatre makers on attachment and under commission, six young writers and comedy groups and we read and see hundreds of shows a year – all in an effort to bring our audience work that amazes, moves and inspires.

'Soho Theatre was buzzing, and there were queues all over the building as audiences waited to go into one or other of the venue's spaces. [The audience] is so young, exuberant and clearly anticipating a good time.'
Guardian

We attract over 170,000 audience members a year.

We produced, co-produced or staged over forty new plays in the last twelve months.

Our social enterprise business model means that we maximise value from Arts Council and philanthropic funding; we actually contribute more to government in tax and NI than we receive in public funding.

sohotheatre.com
Keep up to date:
sohotheatre.com/mailing-list
facebook.com/sohotheatre
twitter.com/sohotheatre
youtube.com/sohotheatre

Thank you

Soho Theatre relies upon the generosity of its audience, Soho Theatre Friends, and donations from a whole range of people and organisations to support its artistic programme and charitable activities. To find out more about how you can help, please visit sohotheatre.com/support-us/.

You can see a list of our current supporters in the box office lobby, and also at sohotheatre.com/support-us/our-supporters/. We also wish to thank those supporters who wish to stay anonymous, as well as all of our Soho Theatre Friends.

Soho Theatre is supported by Arts Council England as a National Portfolio Organisation.

Chris Thorpe

THERE HAS POSSIBLY BEEN AN INCIDENT

OBERON BOOKS
LONDON

WWW.OBERONBOOKS.COM

First published in 2013 by Oberon Books Ltd
521 Caledonian Road, London N7 9RH
Tel: +44 (0) 20 7607 3637 / Fax: +44 (0) 20 7607 3629
e-mail: info@oberonbooks.com
www.oberonbooks.com

A catalogue record for this book is available from the British
Library.

PB ISBN: 978-1-78319-040-9
E ISBN: 978-1-78319-539-8

Cover design by James Illman

Visit www.oberonbooks.com to read more about all our books
and to buy them. You will also find features, author interviews and
news of any author events, and you can sign up for e-newsletters
so that you're always first to hear about our new releases.

Note

The text divides into five intercut sections. The sections marked G, Y and N are performed by the same three performers throughout, each reading the texts designated by one of the letters. The letters are not meant to suggest casting or character, they just reflect the initials of the performers who first performed the text – although 'G' is a woman, 'Y' and 'N' could be performed by either a man or a woman.

The recurring text marked 'Dialogue' can be spoken by any of the performers, two at a time, each taking one half of the dialogue. It could be that different combinations of performers take up the dialogue every time it recurs, but it should be clear that the dialogue is taking place in a different 'place' to G, Y and N's texts.

I've suggested the text marked 'Final Speech' could be spoken in unison by all performers – but it's just a suggestion.

G: I'm listening and I'm not listening.

I'm listening to someone I know well,
someone I have known for years,
telling me, with restraint, something
terrible.

I'm listening to the thing he's telling
me. I'm taking it in, but I'm also
concerned. By concerned I mean
interested, clinically, analytically
interested, rather than as an emotional
response to the content, sparse as it is,
of the thing that he's telling me, I am
concerned with the quality of restraint.
The quality of his restraint. Because
I feel it, also, in myself. The restraint
that's so much a habit it's become how
we operate.

I know this thing, this Incident the man
is telling me about, to be terrible, in
the detail of it, even though the man
in front of me is not telling me the
detail of it. He is telling it as a detail.
As a short series of short sentences
within the body of a larger thing. I
know this thing to be terrible and I
also know this thing, because I said it
was a good idea for it to happen. But
still I need to be told. I need to be told
in an untraceable way. We are both
comfortable with this. And we are both
comfortable with this because we are
aware of responsibilities higher, than

a responsibility to ourselves. And one
of his responsibilities is to tell me, in
person, news like this.

N: He's wearing a white shirt. He's wearing a
white shirt. He's wearing a white shirt and
black trousers. I can never see his shoes.

If I start thinking about where all
the wires go I'll start trying to see
the connections. And because this
is. Because this is possibly a dream.
Because I think this is possibly a dream
it's best not to pull at the wires too
hard.

G: A long time ago now, many years ago
now, I saw this same man, this man who is
standing here, with news of this Incident.
This man now standing in front of me,
in my office in a tailored suit, who has
somehow managed not to sweat on the
way over here, or maybe stood in the
hallway outside letting the air-conditioning
dry him.

A long time ago now, I saw this man
save the life of another man, and a
woman, who, all things considered,
probably deserved to die. I saw him
commit one act of mercy, and years
later, here we are. Look what we've
bought with it.

Y: Imagine loss.

 Imagine something you could have
 been.

G: I do not want to be the only person who
 can fulfil the function I can fulfil, but the
 more I do the job, the more I become
 the only person who can do it. Of course
 somebody else could do this job, could
 and should do this job, but I have a duty
 to that successor. Not just to paper over
 the mistakes of the past but to concrete
 over them and leave monuments there.
 The man in my office swings himself with
 such easy familiarity into the soundlessly
 upholstered leather chair opposite, and
 begins to tell me a terrible thing as if it's
 just a stage in an ongoing process. Which it
 is.

Y: A guy sits on a plane.

G: Years ago we stood on a balcony, on
 a balcony over a square that was no
 longer square because the buildings at its
 edges, the edges of the square, and the
 edges of the buildings themselves were
 so eroded, so pulverised by shellfire that
 there were no straight lines. The straight
 lines and right angles of the square had
 been pounded beyond rubble into a kind
 of dusty softness that sighed down over
 the former edges of the square like sand.
 We hadn't levelled this building because,

I think, there was some agreement, that
there would be a moment for people like
us, so long denied the chance to do so by
the people entrenched in the building,
to stand on that balcony just once as the
proxies of everyone below, and hold up
our arms just once and reflect the people
back at themselves. We were standing on
the balcony. But the people below were
the leaders. I stood on the balcony and
raised my arms with the others and the air
was electric with promise and noise. The
noise an as yet unformed roar, before the
slogans were written that would carry us
all into the future. This unexpected future
where this man is standing in my office
smelling so unfamiliar, so generic, he
could be selling me a hedge fund or a high
class car in any one of a million artificially
cooled spaces across the world.

Y: A guy sits on a plane. Me. I sit on. I am
sitting on a plane. The type of plane, the
make, the model isn't important. It's not
relevant to the chain of events that has
got me there. The design of the plane
becomes relevant later, I guess. Things
like door placement and the precise level
of cladding around the fuel tanks, along
with the position of the fuel tanks, the
landing speed. The tolerances of the struts
designed to support the landing gear away
from the fuselage. Even the carpets. Even
the precise chemical composition of the

artificial fibres that make up the carpets on
the plane, the level to which those fibres
have been tested, how exhaustively. All
these things become relevant. But not yet.

N: The man in the white shirt is standing at
the edge of a wide road, behind a crash
barrier. He's standing at the edge of a
wide and almost empty road in the bright
spring sun and he's part of a crowd. A
crowd waiting for something to happen.
Something big is happening, but the centre
of that thing has deserted us, temporarily,
and faded to just a low rumble in the air.
A vibration in the ground and a few scraps
of something, maybe paper, maybe what
used to be paper but is now ash in the
shape of paper, suspended in still spring
air and a vibration and a low rumble and
someone has to decide what happens next.

The man in the white shirt steps over
the roadside barrier. It's difficult
because he can't use his arms. He gets
one leg over the barrier into the road.
Into an empty six-lane highway. Before
he pulls the other leg over he looks
back into the crowd. The crowd in
which I think I'm the only real person.
Like you do in crowds. He looks back
at me. Right into my eyes. It's a hot
day and he's sweating. Even though
he's thin. He blinks the sweat away.
It's sticking his jet-black hair to his
forehead. His look says something. It

21

says you should be doing this with me.
He isn't smiling.

DIALOGUE 1

– And what did you want them to think
at that moment?

I didn't want them to think anything.

– Why?

They were my means of argument.
They were the tools I was using.
Obviously, dead, they weren't going to
be convinced of anything themselves. I
wanted to use them to convince others.

– But of what?

The failure.

– Of what?

The project.

– What project?

The European project.

G: Years before now, before today, before
this office, the man in front of me stood
beside me on the balcony over the square.
While we stood on the balcony, another
man and a woman whose lives he was
shortly to save were in a room behind us.
This man and this woman knew their time
was finished, that the long, cruel game was

over. They sat in straight-backed chairs, straight-backed, and looked at the guns, and the tired young people, young, like we all were back then, younger than them by far, they looked at the tired people holding the guns and they listened to the roar of the crowd and probably wondered at its difference to the other crowd roar they were used to, that roar choreographed and this one unstructured and raw. The man and the woman sat in the chairs they had imported at the people's expense on the marble floor they had inlaid with scenes from their own lives turned into a flattering national mythology and they waited to play their part. They would follow the tradition of deposed and hated rulers everywhere and in one of several possible ways, die.

Y: I sit on the plane and I'm something like asleep. Or at least in some kind of. I don't know. Some kind of torpor. Aware, but also aware that my higher functions have been shut down. That they're offline in some way. I'm not asleep. I'm suspended between sleep and something that's not true wakefulness but a state in which I can still think. I can still think thoughts. I just can't remember from moment to moment, during the latest thought, what the last thought was.

G: Back then, we thought we were poets.
 Among other things. We thought we were
 poets. It's been suggested that because we
 were poets, or thought we were poets, we
 didn't have a plan. And we used to say,
 when that was suggested, what is it about
 poetry that you think doesn't involve
 structure and strategy? Why is it such a
 ridiculous idea to structure a country the
 way you'd write a poem? That shut people
 up for a while. Not that we were interested
 in shutting people up. We were aware of
 the plurality of views. But when you've
 found a good answer, the question quickly
 becomes redundant. We answer it, we
 progress. The question, of our fitness to
 lead or of anything else, has to be let go of.

Y: There's always something slipping out of
 my grasp. When I reach behind myself for
 the last thought it's always slipping out of
 my grasp. I can feel its edges in my hand
 but when I try to close my fingers around
 it.

 This is all metaphorical, yeah? This is
 all metaphorical.

 When I try to close my fingers around
 the edge of the thought it just slides
 away from my palm. Slimy and hard
 like peeled and unripe fruit. And it's.
 It's gone.

G: That day on the balcony, the man who
 is now sitting in the soft leather chair in
 my office was the one who decided to go
 in. To fetch the two who were waiting in
 the room behind the balcony and bring
 them out onto it for the last time. The
 very fact of being on that balcony had
 turned us into a focus for the waiting to
 see what happened next and also the
 arbiters of what happened next because
 in that situation, someone, for whatever
 reason, with whatever unreasonable faith,
 has to be trusted. The whole country in a
 moment of recoil, and spasm, asks, what
 now? And whoever is caught in the gaze
 of the crowd at that precise moment has
 to step forward and answer. What now?
 This. And we were turned into the people
 they so desperately wanted to see in front
 of them. We were riding the wave of
 something that wasn't yet articulate.

N: The man in the white shirt always looks
 back at me with the same look. He isn't
 smiling. The look's kind of reproachful,
 and amused. But it says, are you going to
 do this thing with me? And it says if you
 don't want to do this thing with me I'm
 still going to do it. I'm going to do it on
 my own and that's fine. I don't even know,
 the look says, the look from the man in the
 white shirt and the black trousers about to
 step forward onto the six-lane highway, the
 look he gives me says I don't even really

know why I'm doing this. It just seems like
something I have to do.

G: He installed them, our former rulers, on
the balcony as a centrepiece. The crowd
shredded their throats. I don't remember
this from the time, I think. It's something I
notice these days when I watch the footage
of that moment. It's a reflex, surely, but
I think I see the woman's facial muscles
contract, her lips, pulled up at the corners
for a fraction of a second. I think I see
her hard-wired response to adulation, her
many years absorbing forced adulation,
standing on this balcony. I think she starts
to acknowledge it as her due, unable to
distinguish in some reflexive part of her
brain, encased in its false world-view,
unable to distinguish between the sound of
forced love and the sound of pure hatred.

We allowed them to stand. Again, we
hadn't discussed this, but we allowed
them to stand for a long moment,
bathed in light and noise.

DIALOGUE 2

– What are the terms of the European
project? In your view?

In twenty years, we're going to be so
inclusive we're going to disappear
like mist. We're going to disappear.
Bite by tiny bite. I can see it coming.

Not many people can, but I can see
it coming. Small compromises, here
and there, and we kill Europe. We
kill Europe with the great European
project. We kill it with every immigrant
that strengthens a religion that isn't
Christianity. We kill it with numbers.
We kill it with every leaking boat that
makes it across the Mediterranean with
a thirsty living soul clothed in black
skin on it and we kill it every time a
young white man sees a face under a
headscarf and wants to kiss it.

In twenty years, Europe is going to be
dead around us.

The people I killed were helping to kill
it. So they had to die. I didn't want to
do it. But it's got so bad that death's the
only way to wake Europe up.

Y: I wake up on the plane.

We come in from the sea in a long loop
over the city, with a tight turn at its
end. One of those turns where it looks
more like the plane's wing dips and the
city itself pivots about the wing-tip.

We're low enough to see the differing
heights of the buildings. I can pick out
the financial district. Fanning out from
the city centre to the south I can pick
out rows of flats. A TV tower in the

distance. For a brief second, for some
reason, all the cars on the bridge seem
to run backwards. Then the bridge is
behind us and a trick of the light makes
the shadows of trees along the edge of
the boulevard look like a huge crowd,
running.

Triangulating from the TV tower and
the nearest span of the bridge, I realise
I can see your block.

N: There isn't a sense, is what I'm saying.
There isn't a sense that all this man's life
has been leading up to this moment. This
moment he's making up as he goes along.
That this man in his pressed white shirt
and black trousers and blacker hair and
skin stretched tight and tea-coloured over
a young skeleton to make him look older
than he is, is facing any sort of destiny.
There's a sense that something is going to
happen, but not that. Not that he knows
what it's going to be. Or even that he
wants to do what he's about to do.

What he's about to do, reluctantly is
take responsibility.

Not with a sigh. Not like a martyr.
But because only one person in this
crowd is going to act on the itch that,
to some extent, they're all feeling.
And everyone else knows that today
it's not them. So by a process of

elimination. Almost a random process of elimination, it must be him. So with a plastic bag, heavy with vegetables, in each hand. A white plastic bag which is one of the only things, he thinks, that the factories are good at making, he steps over the barrier at the edge of the road and he walks forwards.

If he'd known, he probably thinks. If he'd known that in this crowd, of all the people it was going to be him, he wouldn't have gone food shopping first. He wouldn't have encumbered himself with cabbages and onions.

G: In my office now, he makes a gesture. He brings his hand up to his forehead, pulls it down the length of his face. Something unconscious. As if something's just caused him pain. I remember asking him about that gesture a long time ago. Before the balcony even. We were snatching some sleep. Somewhere. A farmhouse in a forgotten village. The worst still to come, even though we'd arrived there that day to find carnage. Everyone who was left, herded into the woods and shot. Suddenly, from a position of utter stillness, he'd pushed the heel of his hand up against his cheekbone on the right side of his face. A robotic movement. What was that, I asked him, there, outside the farmhouse. Are you alright? Are you in pain? I've seen you do

that before. And I remember his response being. Nothing. He wasn't even aware he'd done it.

Y: We straighten out. The wheels drop. The engine note changes. We're coming in, smoothly, to land. I'm coming home. It's a new home. A home I'm coming to having left everything I know behind. But I am coming home.

G: He meets my eye for a second. His hand goes down and he looks up from the desk, where his eyes have been fixed while telling me the terrible details of this Incident, the details that are supposed to be a surprise to us. That we will present as being a surprise to us. And his eye meets mine, and this is what I wish. This is what I wish for a tiny amount of time. It's a very simple wish and it hits me with utter clarity, absolute force. I wish we didn't have to lie to each other. I wish we didn't have to lie to each other that this course of action would be remotely acceptable to our younger selves. I wish we didn't have to lie to each other that we've stayed true to something. I wish we could admit that the people inside us, those young people who stood on that balcony have, some time between that moment and this, died.

N: The man in the white shirt is about four or five steps into the road now. He's reached

the broken white line between the first and
middle lanes.

He stops. He only stops once on his
way to the middle of the road. This
will be the last time he stops before
the last time. So he makes the most
of it. He stops and shifts his shoulders
slightly in the sunlight, as if the weight
of the shopping bags, one white plastic
shopping bag in each hand, has made
the muscles in his shoulders start to
ache. I know he's not thinking this, how
could he be thinking this, but they're
the same set of muscles that would
ache if you were yoked to something.
If you were pulling a plough or trying
to win a competition as a strongman
or climbing a hill with a cross on your
back. He doesn't know this. He's just a
man who walked into a crowd while he
was carrying his shopping home.

Y: I know this. I know landing.

G: From the balcony, the noise congealed
 into peaks and troughs. The first new chant
 of a new era. The crowd, seeing the old
 man, the old woman. Seeing their former
 rulers, has made its first decision about the
 new state of things, and that decision is.
 Kill them.

N: The man in the white shirt stops and
 lifts his shoulders, and then he lets them

relax. They're slightly lower than they were before. Not because he feels more put upon, I think. Because he's more comfortable now. He's broken from the crowd. The decision has been made, and from the increasing vibration through the soles of all our feet we can tell there would be no going back for him anyway. Not at this stage.

When he's settled. When he's comfortable, he turns for the last time. Fully round so that he's standing, facing back the way he's come. As if he's going to address us. He might be smiling. It's hard to tell. The sun is almost overhead. But he opens his mouth like a sudden crack in the bottom of his face. A hinge into blackness.

He looks straight at me. He's speaking, without speaking. Without moving.

Y: The lights below get sparser, apart from the bright arterial slash of the ring road. I can still see your block in the distance. The ring road, then a kind of no-man's-land with a few scattered houses, cheap because of the constant noise of planes that shakes them. Then a couple of hundred metres of pure dark, a car park slipping by, cars like a thousand discarded bottle caps left at the edge of a playground. The line of the perimeter fence weakly shining with razor

wire, I guess, and electronic sensors, or at least enough of the illusion of both those things to make us all feel safe enough to fly. The terminal roof. The runway below the window. The first, the second bump of the wheels.

The third bump of the wheels. The nose wheel.

And it's a funny thing. Because you think you don't know systems. You think you don't even notice systems. But the tiny part of you that marks them. That says to yourself, inaudibly, I've been here before, and what happens is this, and then this, and then, depending on the circumstances, this. That tiny part of you knows when something has gone even slightly awry.

And that tiny part. The one that could tell you on a cloudless night if one of the stars was out of place, even though you rarely look at the stars. That tiny part starts to itch in the back of my brain and I think of you. I mistakenly think that the landing has prompted me to think of you, waiting on the other side of security, hopefully. And that the bump of being here, actually being pulled by gravity against the same landmass as you for the first time in a long time has shaken loose questions in my brain that were less securely

fastened down than I'd thought. And I actually misinterpret the disquiet as something I've been thinking quietly all along, which is – was getting on this plane the right thing? Are we going to look at each other and have to cover up the fact that this has been, in some way, a huge fucking mistake?

DIALOGUE 3

– And during the attack, you disguised yourself?

Yes.

– Why?

So I could get close enough to kill them.

– And what did you disguise yourself as?

A Muslim woman.

– And what gave you that idea?

It's a tactic the Taliban use.

– You borrowed tactics from the Taliban?

I've got no problem with that. They're a very effective fighting force. I wish the networks defending Europe were half as organised.

– Could you expand on the tactic?

In Afghanistan, women are perceived as a lesser threat. So they disguise their soldiers and their suicide bombers as women sometimes. So they can get closer to checkpoints and buildings before they attack. It was also a statement.

– Would you like to clarify that?

The liberal establishment doesn't see Islam as a creeping threat. It makes allowances. It refuses, generally and individually, to challenge Muslims, and particularly Muslim women.

Ironically, one of the reasons the authorities won't challenge Muslim women is because they know deep down how oppressed they are. Their tacit acceptance of male oppression due to obsessive cultural sensitivity means that the figure of a Muslim woman is the perfect means of attack.

So it was also a statement. I took on the form that symbolises the creeping Islamification of Europe.

– They banned the burqa in France. How does that fit into your thesis?

Look at the trouble that caused. Many of the liberals and the marxists are

so culturally conditioned that they'll fight Islam's battles on its behalf. One country bans one manifestation of oppression and we're already so well trained that ethnic European multi-culturalists shout first and shout loudest.

– So that was your thinking?

There was also a logistical aspect.

– What was that?

You can hide more guns under a Burqa. As clothing for terrorism, it's very practical.

G: And, on the balcony that day, this is what happens. The moment that leads us to now, to here, today, this office, and what we have become. On the balcony, unexpectedly, to all of us, the man, the woman, the people below, himself, he makes the involuntary gesture. Lifts his right hand to his face. But the crowd, of course, don't know it's an involuntary gesture. Completely by accident, he swears later, the hand says. Silence. That's what the crowd interpret. And the crowd obey. And he says. This isn't about what we want right now. This isn't about revenge. I can't speak for all of you, I can't even speak for everyone standing here with me. This balcony makes no difference. We haven't had time to discuss anything. Not

that it's our decision. But what. What do you want? And the crowd say. Kill them. And he says I'm not here to tell you what should be done. And the crowd say. Kill them. And he says. All I'm saying is, think. And the crowd say. Kill them. And he says. Not yet. Let's think about the kind of society we want to build, now we have the chance. And someone in the crowd says, they've been killing us for years. And he says, yes. But do we want to go on living by the rules they created? And the crowd think. They genuinely think. And in that moment the people on that balcony become something else. We are separated from the crowd. We are holding our former oppressors at gunpoint. And we are also the crowd's hope, personified, and the new leaders deposing the old. In that moment this desk, these chairs, this office, the art, the carpet, him sitting there and me sitting here and all this, this moment, all become somehow inevitable.

Y: Has all this been, in some way, a huge fucking mistake?

 But that isn't actually what that tiny part of my mind is telling me. What it's telling me, quietly, is that if this is a normal landing we should be slowing down right now. And we aren't. Not enough. And it tells me this before any

of the external indicators of disaster are
noticeable at all.

G: The crowd no longer says kill them. It
isn't a change of mind, a complete change
of mind in this one symbolic instant.
Although of course it's presented as that,
soon afterwards and for years afterwards,
by people who, mostly, weren't there.

Y: We should not be going this fast.
Something has happened. Or something
has failed to happen.

G: Something in the appetite is gone. There's
a shift. A feeling, I think, that we, the
random collection of tired and ragged
people on the balcony, flanking our
former oppressors, have somehow taken
responsibility. That we're being given a
chance. If we're going to set ourselves
apart. If we're going to refuse to do what
the moment demands, then we had better
damn well make ourselves responsible.
We'd better. We'd better fucking well, the
crowd says. Ridiculous I know to treat
a crowd like a thing of single intent, but
there it is. We'd better fucking well have a
plan.

N: I think I'm the only real person in this
crowd.

In the seconds that the man in the
white shirt stands there, he might have

said. He might have said a lot of things.
I know I don't speak the language
he grew up speaking. I don't know
if he speaks the language I grew up
speaking. But he could say. He might
say. As if he's addressing me. Or the
whole crowd. All of us. He might say.

This is a photograph waiting to happen.
A photograph in which no one will
ever see my face. In which I won't be
recognised. And that's fine. I'm fine
with that. With the anonymity that
comes from being a symbol. A symbol
of something. Of heroic. Heroic failure,
I guess. But that's OK. I just want
to. I don't know. In the time I have
left, which isn't very much, but in the
time I have left before things become
truly uncertain. Before I become a
photograph but also before what
happens afterwards happens. So before
I become an utterly fixed point and
also a mystery. I wanted to say some
things.

But not my name. If you know my
name then everything about this
becomes pointless. I'm going to be
much more powerful, longer lived,
whether I survive or not, as the guy
who did this. Rather than a name.

Y: We're not slowing down.

N: Also, I wanted to say, I can see slightly
 further down the road than you. And
 as a result I'm in a position. A physical
 position, I mean. To give you some
 insight. Into the situation. I don't mean the
 political situation. The current upheaval.
 I'm not saying further down the road.
 That I can see further down the road if
 the road is the future. I mean I can see
 further down this actual road than you.
 Actually round the next corner. And while
 we all probably know what that rumbling
 sound is. The one that's getting closer. I
 can tell you, from my uniquely privileged
 position here, in the centre of this road, on
 this beautiful day. The day after the bulk
 of the protesters were shot. I can tell you
 something.

 Tanks are fucking big.

DIALOGUE 4

– So you consider yourself a terrorist?

In a sense, yes. In another sense, not at
all.

I'm a terrorist in that I've borrowed the
language of terrorists. The language
of death. But I've used it for my own
ends. I've used it in love. For love of
Europe.

I'm not a terrorist in the sense that
terror was my main motivation. I

wanted to create a pause. A horrified,
fearful pause, I suppose it will be,
initially, but eventually a pause for
reflection. The people I shot were
terrified. I looked many of them in
the eye. I saw how terrified they were.
Too terrified to move, a lot of them,
especially the younger ones. Too
terrified to beg. So I suppose in the
commission of the actual attack, in the
time-frame of it, yes I was a terrorist in
that I caused terror.

But that was never my motivation.
And any terror I caused in the moment
was short-lived because the people I
terrified, soon after, I shot.

But terror isn't a useful emotion
now. Now is a period of reflection. I
had to create the storm in order for
the calm to exist. I hope people will
use that calm. Because what I did
to the Parliamentary Youth Meeting
was only a small fraction of what
multiculturalism will do to Europe.

Liberal hypocrisy is going to condemn
me. I'm comfortable with that.

Y: Something has happened. Or something
has failed to happen, and we're not
slowing down. I'm not scared knowing
this. I'm not even sure if anyone else has
noticed yet. We're not communicating

on that level. The passengers. The lights charging past us at the margins of the runway are flickering less frequently and some logical part of my brain, fully awake now. Some logical part of my brain is realising that this is not because we're slowing down, finally, but because they're more widely spaced. There are fewer of them.

N: Tanks are fucking big. And I wish I'd put my shopping down. But I can't do that now. Because the weight of these cabbages is the only thing stopping me from running away. The only thing keeping me on the ground.

 If I dropped these bags I'd start to run and I don't know when I'd stop.

G: And so we fall into it. Or step into it. On that balcony, on that day. Making promises designed to at least make it appear we know what we're doing.

Y: Maybe they just forgot to lock the laws of physics.

 I have time to think this. And some other stuff. Some stuff about my family. Some stuff about what the fuck I've done with my life. Some stuff about what it means to be landing on another continent in the dark. About how the threads of everyday life will

be woven slightly differently here.
Same mechanics. Same biology and
commercial transactions and the laws
of thermodynamics operating at the
fundamental level but different insects
and –

And of course it can't last. Of course
we run out of runway.

G: We knew the answer needed to be better.
It has taken us years to realise the answer
would include this day, now. This news.
This Incident.

N: The man in the white shirt. In the mind
of the crowd, suddenly reveals himself to
have magical powers.

Y: And of course we run out of runway. One
almighty bump and everything's blurred
because the vibration moves our eyes
in their sockets too fast for our brains
to compensate. Then a split-second of
falling as the landing gear gives way. Then
we're still travelling. We're still going
forward, and I'm thinking at least this is
progress. We smash through something
and somewhere in front of me the plane
cracks like a picture. The walls part and let
the night in. We grind across something.
Gravel, or a road. There are sparks.
The night breeze sours with the smell of
something chemical. And we stop.

N: The man in the white shirt was definitely the right person to walk out into the road. If someone had to at all. Because it turns out the man in the white shirt can stop tanks. It turns out that the man in the white shirt just has to stand in the middle lane, on the tarmac, on a sunny day, a day with even more smoke than usual in the air, while yesterday's bodies are being cleared less than a mile away and the whole place is quivering with the shock of what's happened. Of tens of thousands of voices all raised, briefly, at once and then stilled with gunfire. This one man can stand alone at the centre of all that and find a place of stillness, and a column of tanks, not just one tank, but a whole column of tanks in single file with their bulbous skulls and their guns protruding will stop in the road in front of him and give him what looks suspiciously like respect. Or at least they won't run him over. For now.

G: Of course, after that moment, the balcony, we began to learn. We learned, for example, that for something worthwhile to happen it's simply not enough to wish the situation to be otherwise.

DIALOGUE 5

– You mention the Parliamentary Youth Meeting?

Yes.

– Why was that your primary target? The meeting was in the Parliament building after all.

Two reasons. Security and impact.

– Security?

The Youth Meeting meant there was a large concentration of people close to the entrance hall. It meant there was one less security checkpoint to shoot my way through.

The impact came from the fact I would mostly be killing young people. If I'd killed politicians, people would have sympathised with me too much. A generation that's already in power is already compromised. Everybody wants to kill politicians at some point. I wanted to draw attention to the fact that the young are already making the same choices. That the European Project has indoctrinated teenagers and younger people to the extent that they aspire to be part of the project rather than follow the natural inclination of youth and rebel against it. By those terms, the young people at the Parliamentary Youth Meeting had already compromised themselves. They would be a much more useful illustration to other youths yet undecided. They were already dead.

Politically. But their youth meant more impact.

– Do you think –

Also, the make-up of the group was aggressively multi-cultural.

– Do you regret –

No. Obviously there are things I would rather not have done. I would rather not have killed. I'd rather live in a saner world that meant my actions were unnecessary. But I don't. I live in a mad world where the idea of Europe is the thing that's killing Europe. Where co-operation has been twisted into an open door, and the values that equip us for the future are being diluted in the name of tolerance.

For example, at one point in the massacre I shot a girl called Julie Forrester in the forehead. I didn't know her name at the time. But now I know she was a twelve-year-old who led a community project at her school for the integration of immigrant children. I can see her father there, today, in the gallery. I recognise him from the news. Julie Forrester was trying to hide under a plastic chair. I lifted the chair off her gently, and she looked at me, and I blew the top of her skull off. I don't

mind telling you that at that moment I felt like crying.

If I'd enjoyed doing that, yes, I'd be a monster. I'd be worthy of execution. Hang me. But I didn't.

But Julie's death meant something. As did all the others.

So no. Of course I don't regret it.

I killed her, and all the others, to create the Europe I believe should exist.

Not the Europe that thinks the problems of the world can be solved by dialogue.

G: It's simply not enough to wish the situation to be otherwise.

N: When it comes down to it, this man is only a collection of atoms. He's matter arranged in a series of matrices. What stops the tanks in that moment. The tanks that are after all made of different combinations of the same stuff as the man, is what he has made himself mean.

G: Later, when the man and the woman were safely locked away. When their crimes had been listed, and they were safely locked away to live out their remaining lives, their short remaining lives, as it turned out, we realised what that moment on the balcony had bought us.

Y: There's a moment of silence. Which just
 turns out to be a brief and bitter segue
 from something bad into something worse.
 And then noise. And panic.

 I'm polite. I'm polite in the face of
 disaster. I'm surprised. That it's the
 disorganisation that upsets me. The
 fact that this isn't dignified. There's
 obviously an efficient way of us all
 getting off this plane. And this isn't it.

 Every one of us. Me, the fat guy across
 the aisle. The woman who I walked
 past to get to my seat. We're these bags
 of desire. Of desire held in by skin. But
 there's no excuse for this that I can see.
 Nothing is on fire. There's a strange
 chemical smell. But nothing is on fire.
 If there was fire I could understand
 it. Maybe I'm missing a gene. Maybe
 history's littered with the bodies of
 idiots like me, petrified under volcanic
 ash or picked clean in the cabins of
 boats on the sea floor. Mouths frozen
 in the act of saying something like I'm
 sure if we all just take a deep breath
 and take a moment to look around,
 we'll get out of here much more
 smoothly. And when the sentence is
 finished we look up to see the exit
 blocked by falling rocks.

G: As the years progressed, I found I had an
 aptitude for it. Leadership. The strange

out of order thinking needed, to lead.
And the careful language needed, equally,
to express that thinking. Behaving as if I
had been sure all along what exactly we
needed to be. As if there was a future we
were planning for. And we had an easy
ride of it at first.

Y: The ragged gap in the fuselage extends all
the way round. I stay in my seat. There's
a press of people, forced into a kind of
desperate queueing system by the aisle
that stops abruptly just after the wings.
With a kind of grim hopefulness they're
dropping, one by one into the darkness.
Some of them are sobbing. I'm not
sobbing. I'm waiting. I'm doing mental
arithmetic. A kind of mental arithmetic
anyway. I'm visualising how the plane
is resting on the ground. The points of
contact. I'm calculating the tilt in the
floor, the additional height that gives us.
I'm subtracting the fact that the wheels
have collapsed, adding the softness of the
ground, the weather outside. Noting that a
light rain has begun to fall.

G: I have done what had to be done. One
day I will step away. When I've done
enough. When there's enough achieved to
let someone step easily into this office after
me. But now, I'm still acting in the present
to structure the future. And that future is
still something I believe in.

Y: The drop's maybe ten feet onto what looks like wet grass.

N: The man in the white shirt stands in front of the tanks. There's no breeze. The tanks' engines stop. One by one. The man in the white shirt stands and the silence bursts away from him, forwards away from him and the engines of the tanks stop one by one like dominoes falling. He's exploded. I think. The man in the white shirt has exploded on some subatomic level and the wave of that explosion carries silence. He eats sound. The man in the white shirt eats unnatural sound. So the tanks stop, and nobody in the crowd speaks and there's just ragged breathing and birds wheeling through smoke between us and the blue sky. There are hidden stars up there. Eclipsed eternally by the day. I think there are always stars shining, even in the day. And I think I haven't called my mother in a while and I think and I think, the stars, the ones that shine in the daytime, don't care that we don't see them and nothing apart from us in the universe cares about the imposition of will or how one chance arrangement of atoms can communicate ideas that cause other arrangements of atoms to do their bidding and change their internal, electrochemical structures in a way that says this is a memory, this is an idea, this is a new idea this is an action and this is what we call politics and this thing,

this life, this series of acts is the thing it
shapes.

Y: There's a boy in the last row of seats. I
 thought I'd be the last person jumping off
 this plane but as the fuselage cracked I
 guess it twisted, crimping the last two rows
 together.

 The lights have gone off. It's just me,
 standing in the aisle, the boy. Me and
 the boy. Lit by the orange glow from
 the clouds and the distant light of
 emergency vehicles, getting closer.

 He's awake. I'm in no rush. I squat next
 to him and I look him in the eye.

 He's not speaking. He's sweating. He's
 not speaking. His hair is plastered to his
 forehead with sweat.

N: And the stars don't give a fuck if we
 can't see them during the day, and in
 that moment, that moment of stillness
 and heady possibility I think, too, I
 think fuck the stars. Fuck them. Those
 nodes of stuff where hydrogen fuses into
 helium and helium fuses into lithium and
 oxygen and further up the line to iron
 and energy results, and planets result
 and sunshine and proteins and wings and
 legs and fingernails and powered flight
 and pre-sliced meat and coral reefs result
 because at the end of their lives some of

the stars tend to explode, scattering what
they've made and making everything
that's heavier than iron in the process.
We're apparently all made of that stuff,
apparently the stars, old stars now dead
made us and that's just something that
everyone knows these days, that's an idea
so accepted and unquestioned it's a cliché,
that we are the Universe and the Universe
is us and matter connects us all. And the
stars are the parents of everything. And
that connects us. And life, the very fact of
being alive will always mean we are more
the same than we are different.

And I think fuck all that. Because this is
a guy standing in front of a tank.

Yes. All that probably happened, but
this is a guy standing in front of a tank.

All that is meaningless. All that is
invalid because.

Because here is a guy. In a white shirt.
With a shopping bag held in each hand.
Standing, nameless forever, in front
of a fucking tank. And so. Universe,
you neglectful fucking parent, here we
all are, silent. The stilled tanks with
their operators inside. The crowd,
sweating in the sun, and at the focus
of it all, this one man. Already the
most powerful thing on the planet by
accident. Already clicked into nameless

immortality by a camera shutter on a
hotel balcony half a mile away. Tell us
what to do with our heroes. Because we
don't know what happens next.

G: When I had to close the first newspaper,
I did it because I believed in a future
defined by free speech. When I asked for
calm and quiet for the sake of stability
I believed in a future defined by the
freedom to protest. The jail terms were
brought in because people apparently just
won't listen when we say that change is
an ongoing process. That change is not
something that happens overnight. Not
if you want it to last. It's not my fault. I
told them loudly and honestly. People
won't listen because that's how people are.
And I said to the ones who objected to
the jail terms, what would you rather we
did? Remember that day on the balcony.
Always remember that day on the balcony.
This is just a temporary measure. We
aren't murderers. We don't even murder
our enemies. You wanted that. I'm only
here to see my part of the job through and
no more.

Y: I squat down by the trapped boy. It's
ten feet to the ground. Two bodies won't
accelerate over that distance much more
than one. So I put my arms round him,
under his shoulders, and I pull. He grits
his teeth and makes a small sobbing sound

against my chest. Something, down there between the rows of seats that are far closer together than the designers ever meant them to be, is stuck. I pull again. Something gives, but not much. Enough to let me know that I could pull him free. But this time, he screams. And I stop pulling. Because there doesn't seem to be much point causing him pain when there's just a few yards of grass between him and rescue.

G: And I believe that. I'm only here, still, because I haven't finished safeguarding the future. As the man sitting opposite me tells me that the Incident, what had to happen, has happened. That on my orders, my deniable orders of course, but still my orders, a small number of officers in one part of the army in a single city on the border full of spies and liars and agitators have shot some young soldiers who refused an order to fire on a demonstration. And then the army fired on the demonstrators anyway. They fired on the demonstrators anyway because I decided that had to happen.

Y: The lights outside are getting closer. There are a lot of vehicles out there. I can feel the vibration through the floor.

 We don't have time for a long conversation. Me and this boy. We don't have time for a long conversation.

I don't even know if he understands
me. I don't ask him about his family.
I don't even ask him his name. But
I say something reassuring. About
there being time. And something half
thought-out about cutting equipment
and those flashing lights and about
how the orange glow is just the lights
of the city I am moving to. The city
I'm moving to that isn't my city but has
someone in it I very much want to be
with, to the extent that I've left my old
life behind.

I drop out of the plane into the light.
I walk towards the vehicles. Towards
blanket-covered figures with an orange
glow at my back.

And I wonder briefly why everyone is
running away from me.

And behind me, the plane explodes.

N: Something has happened, or failed to
 happen.

 And I think I'm the only real person in
 this crowd.

G: Of course there'll be no trace of my
 part in this. The officers will be shown
 to have been acting alone, and they
 will be punished. The officers will say
 they were told it was policy. But there'll
 be no record of it. We've become very

good, over the years, at erasing the
chain of command, up to and including
conversations like this one. Because who
in their right mind would order officers to
execute young soldiers acting according
to their conscience? And who in their
right mind would order soldiers to fire on
demonstrators? It happens. But who in
their right mind would order it? Not us.
No matter how bad things get. So when
it happens we're as appalled as anyone.
I'm as appalled as anyone. And the
demonstrators will still have been shot.

And I will sit in this office. I'll sit in
this office until everyone is so free, so
fucking free that nobody will ever have
to be tortured again.

We started this with an act of mercy. A
public act of mercy. Accidentally. One
arm movement from one tired man,
but we all stepped forward behind it. I
stepped forward, as it turns out, further
than the others.

We started with an act of mercy, a
public act of mercy. When perhaps we
should have shared something else.

We started with an act of mercy. A
public act of mercy. I don't know.
I don't know. I don't know if we
shouldn't have killed them. Thrown

their bodies from the balcony to the crowd and started as we had to go on.

And now, today, there's another crowd below. I need to go and explain to them, that despite this Incident. This regrettable Incident. That nothing has changed. We're still. We're heading in the right direction.

DIALOGUE 6

– What would you say your state of mind was at the moment you started your attack?

My state of mind?

– Yes. Do you want me to put the question another way?

If you think it'd be useful.

– Can you remember what you were thinking and feeling at the moment you pulled the trigger?

Life changes. Life changes when you put into action what you believe.
All the planning, all the theorising is wasted if the courage isn't there when it's time to put it into practice.

– That's was you were thinking?

Perhaps not precisely that. But that was the overriding feeling. That this was

the moment that would make all the planning worthwhile, or not. This was the pivot.

I didn't kill those children. Their choices, and the choices of their parents and their leaders, meant they were effectively dead already. All I did was give their deaths a chance of meaning something.

I gave them an opportunity.

FINAL SPEECH

Performed in unison by all performers.

He comes across the floor of the entrance lobby. Of course at that point, I don't know it's him. He's dressed as a woman. His face is covered. He looks like nothing out of the ordinary.

I don't mean this to be. Dismissive. It's just that when you see a lot of people it really takes something particular for one of those people to stand out. His face. His body's hidden. I guess it was a costume. He was pretending, wasn't he, to be something he wasn't.

I think. I can't believe now I think this, but I think. I think the gunshots are music. Drums and hand-claps.

I'm trying to remember if there's. I don't know. Some kind of performance

scheduled. Or a demonstration. Some of them can be pretty. Out there. You know. Pretty weird. You don't know what it is they're actually upset about until you think about it. Unpick it a bit. Sometimes, not even then. Of course, it's not really my job to understand it. It's something that goes on where I work.

I think the falling people. Mostly children.

I think it's dancing. I think the falling children are dancers.

Of course this doesn't last more than. More than seconds. I see what's going on. And the strange thing. The strange thing is it is as if he's dancing. The black cloak, or whatever. That he's wearing billows out around him as he spins.

It's a beautiful piece of architecture. High. Wide. It reflects. On and on. It's got these ribs. It's a bit like being in a whale skeleton, a bit like being in a station. But it feels like the kind of place where important things get done.

So in that space, it sounds important when the first grenade goes off.

A teenager lands in front of me and spills all over the floor. And I am

running. And I am running. Clearing broken chairs.

He stands over a girl. He stands over a girl in a blue denim dress and I hope his concentration is so total he neither fires again or looks up before I get there. I think I hope that. I might not have, though. I probably. There was probably no thought.

I should have been thinking of my own daughter. As I ran towards the girl I maybe should have been thinking of my own daughter. Imagining her in that situation. But if I'd started thinking of her, of my own daughter, I would have stopped. I know I would have stopped. Because the answer to – what would I do if it was my daughter in that situation? – is – this girl in the blue denim dress isn't my daughter. And that would have stopped me I think.

I think I shouted.

It's true. Anyone would have done.

Anyone would have done what I did in the same situation.

I honestly believe that.

I have to believe that.

I shouted. He turned towards me. Between us at this point there is a table.

There are two teenagers under the table. I think one of them is already dead. I jump the table. From this point on, after he has turned towards me, as I start my jump over the table, from the moment my feet leave the floor, we have eye contact.

There's no surprise. He isn't surprised to see me. It's like I'm an expected part of the situation. A factor he's already considered. A mechanic of the game. Someone will always do this.

And this thought. Weird thought. Why am I thinking of my daughter? I don't have any children.

And immediately following now. Another thought. It doesn't matter. I don't have any children and it doesn't matter because children are children. Nothing makes these children special. Nothing would make my children, if I had them, more special than these.

It doesn't matter.

I was flying over the table, arms stretched out towards him, when he finally shot me.

Two bullets. Two bullets equals three fingers and an eye. It's not a bad sum. Two bullets take three fingers, one eye, and my momentum carries me onto him and we fall. And his gun falls. And

I'm holding onto him with one good hand. Ramming my forehead into his face over and over.

Then suddenly there are other arms on him, and on me.

I dream about that.

It wasn't what I did. Or at least it was only what I did first. I had the opportunity. In that sense it was lucky. But without those other arms it would have been impossible.

The girl? She.

The girl. She died. But she was the last one. That day. She was the last one to die.

I did that. I stopped it. Not on my own. And too late. But I did that. At least I did that.

Printed in the USA
CPSIA information can be obtained
at www.ICGtesting.com
LVHW021002171024
794056LV00004B/1289

9 781783 190409